5 Art Lessons With Anna M. Brown

TEACH Yourself to DRAW

Forest Animals

Teach Yourself to Draw

The Thinking Tree, LLC

Copyright ©2014

TeachYourselfToDraw.com

Artistic Illustrations by:

Sarah J. Brown and Anna M. Brown

Copyright Information

Teach Yourself to Draw Activity Books, and electronic printable downloads are for Home and Family use only. All other uses of this material must be permitted in writing by the Thinking Tree LLC. It is a violation of copyright law to distribute the electronic files or make copies for your friends, associates or students without our permission.

These books are not permitted for classroom use and copying without written permission. For information on using these materials for businesses, co-ops, summer camps, day camps, daycare, afterschool program, churches, or schools please contact us for licensing.

Contact Us:

The Thinking Tree LLC

617 N. Swope St. Greenfield, IN 46140. United States

317.622.8852 PHONE (Dial +1 outside of the USA) 267.712.7889 FAX

Email info@teachyourselftodraw.com

Teach Yourself to Draw
Forest Animals

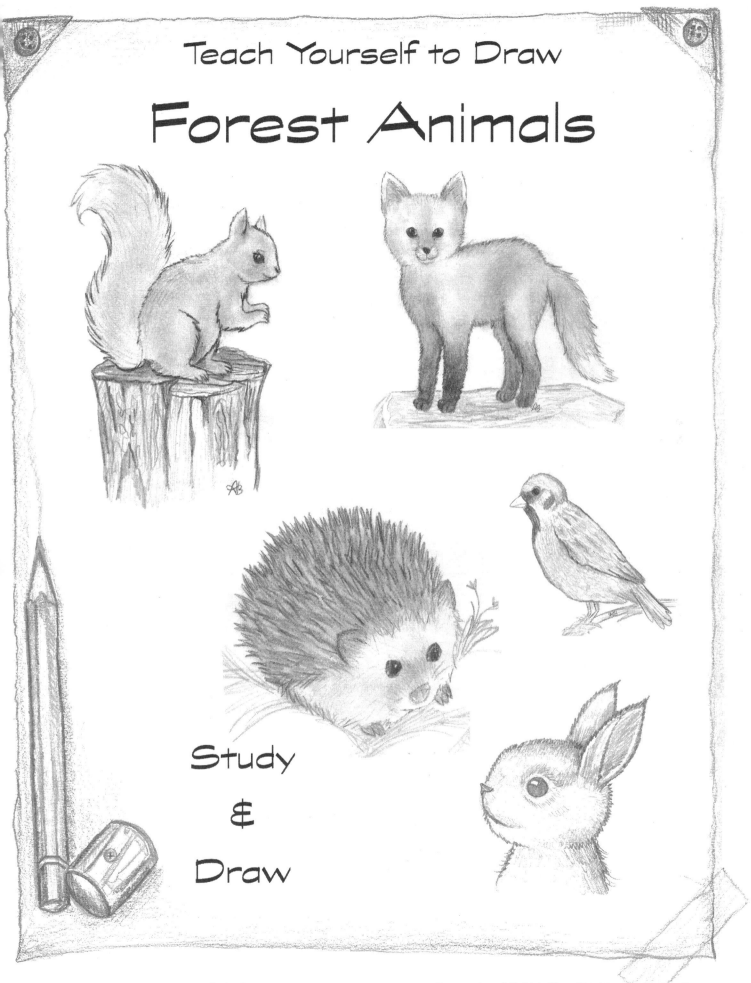

Study

&

Draw

Teach Yourself to Draw
Forest Animals

INSTRUCTIONS:

1. You will need at least two pencils: a #2 Pencil and a darker, softer pencil, (5B is best). Make sure your pencils are very sharp.

2. Take a long look at the artists drawing of each animal, be sure to think about how all the little pencil strokes work together to create the drawing.

3. Follow the instructions on each page. As you trace the artist's drawing and draw the missing parts you will develop the skills to draw realistic animals. The practice with these books will train you to do your own drawings

Learning From the Animals

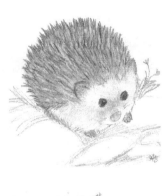

"Ask the animals, and they will teach you, or the birds of the air, and they will tell you; or speak to the earth, and it will teach you, or let the fish of the sea inform you. Which of these does not know that the hand of the Lord has done this? In His hand is the life of every creature and the breath of all mankind."

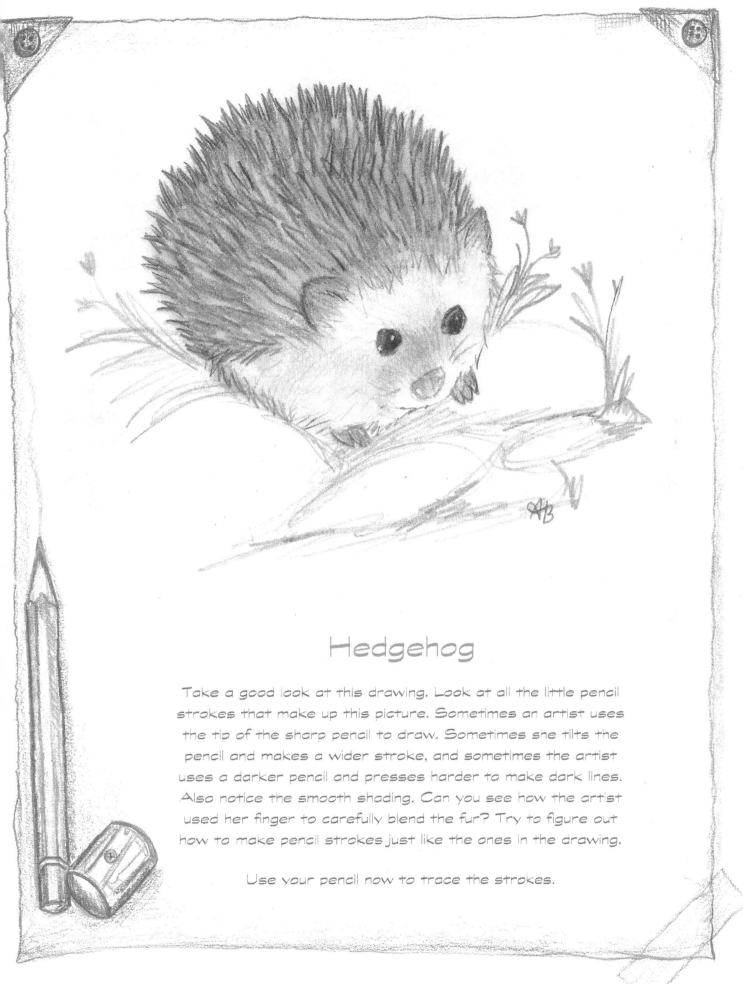

Hedgehog

Take a good look at this drawing. Look at all the little pencil strokes that make up this picture. Sometimes an artist uses the tip of the sharp pencil to draw. Sometimes she tilts the pencil and makes a wider stroke, and sometimes the artist uses a darker pencil and presses harder to make dark lines. Also notice the smooth shading. Can you see how the artist used her finger to carefully blend the fur? Try to figure out how to make pencil strokes just like the ones in the drawing.

Use your pencil now to trace the strokes.

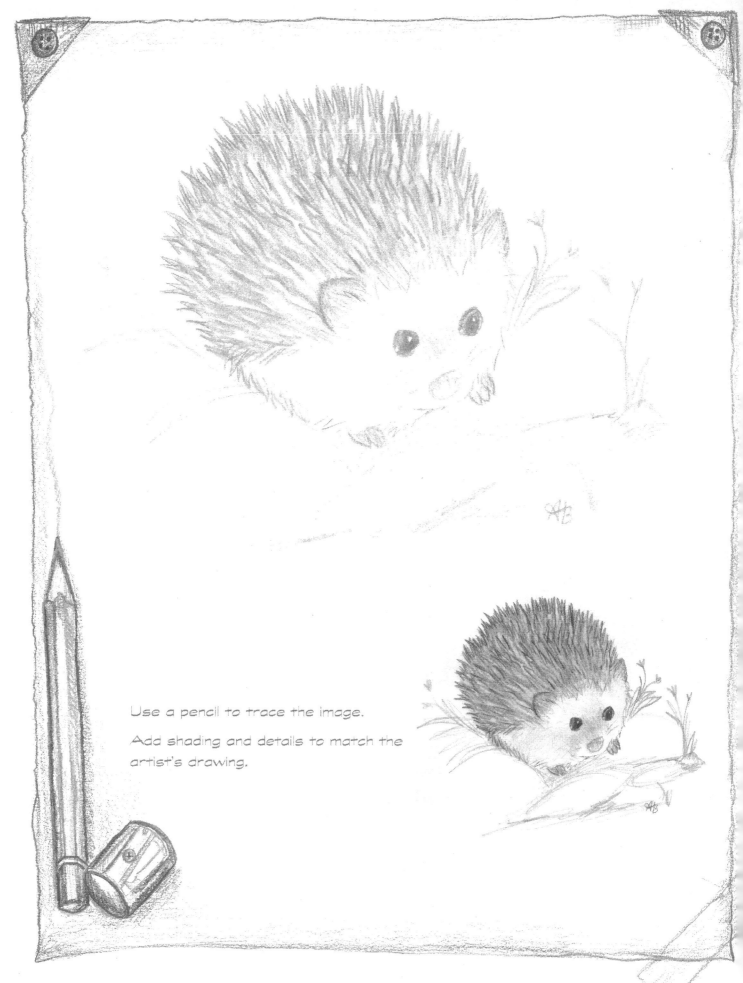

Use a pencil to trace the image.

Add shading and details to match the artist's drawing.

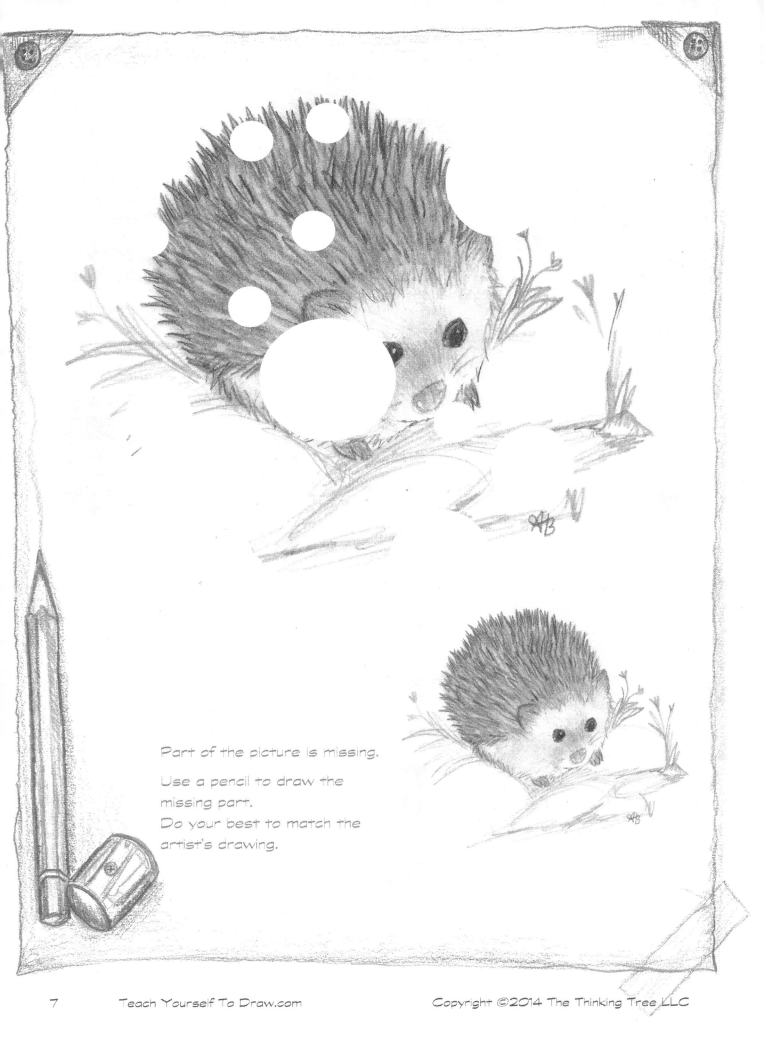

Part of the picture is missing.

Use a pencil to draw the
missing part.
Do your best to match the
artist's drawing.

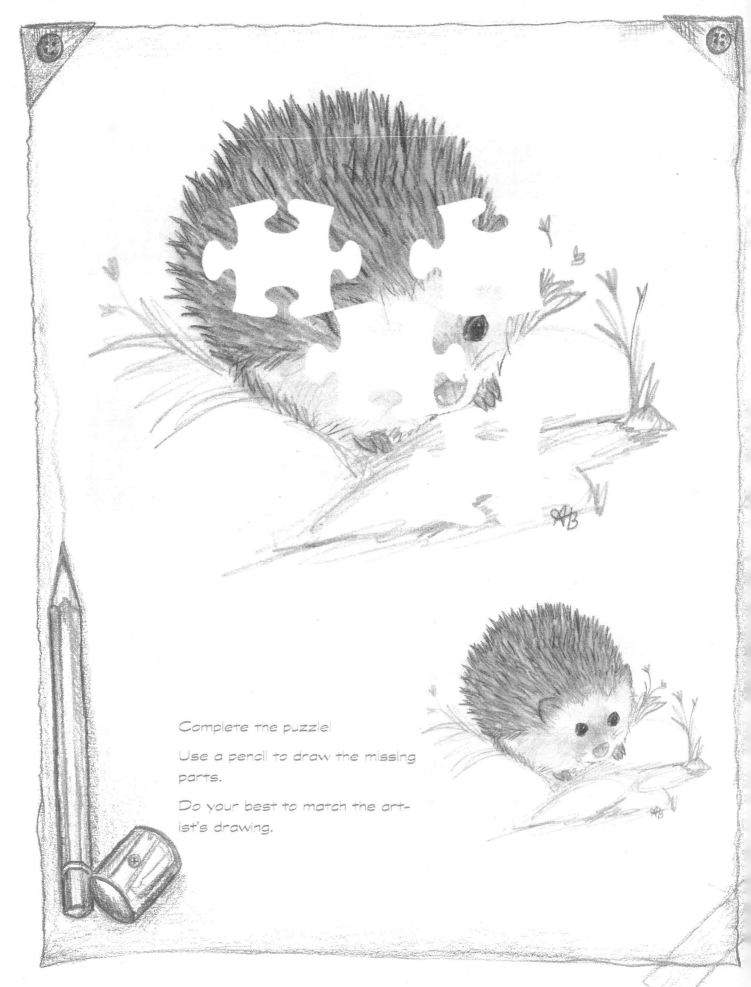

Complete the puzzle!

Use a pencil to draw the missing parts.

Do your best to match the artist's drawing.

Teach Yourself To Draw.com

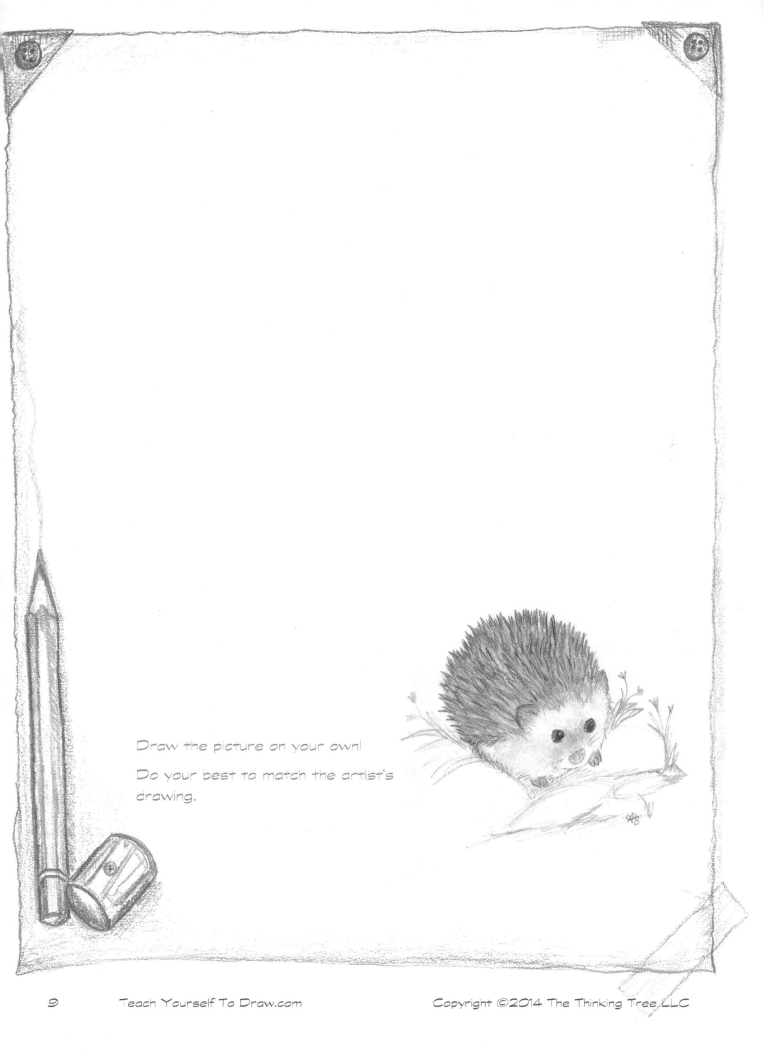

Draw the picture on your own!

Do your best to match the artist's drawing.

Now that you are learning to draw like an artist,
it's time to keep practicing!

Teach Yourself To Draw.com

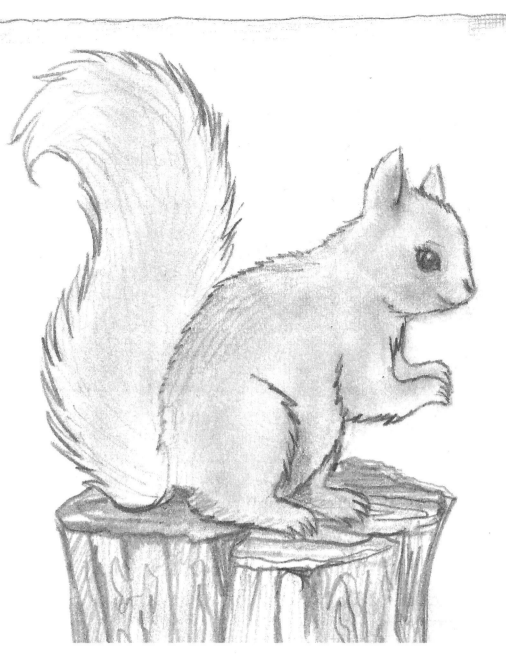

Grey Squirrel

Take a good look at this drawing. Look at all the little pencil strokes
that make up this picture. Sometimes an artist uses the tip of the
sharp pencil to draw. Sometimes she tilts the pencil and makes a
wider stroke, and sometimes the artist uses a darker pencil and
presses harder to make dark lines. Also notice the smooth shading.
Can you see how the artist used her finger to carefully blend the fur?
Try to figure out how to make pencil strokes just like the ones in the
drawing.

Use your pencil now to trace the strokes.

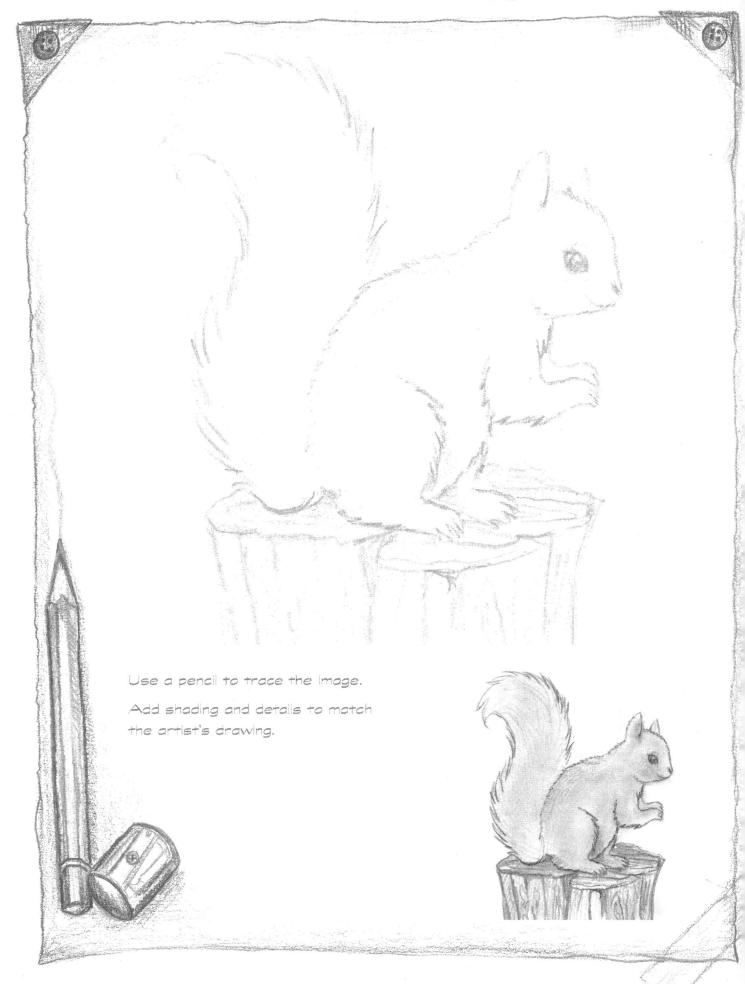

Use a pencil to trace the image.

Add shading and details to match the artist's drawing.

Teach Yourself To Draw.com

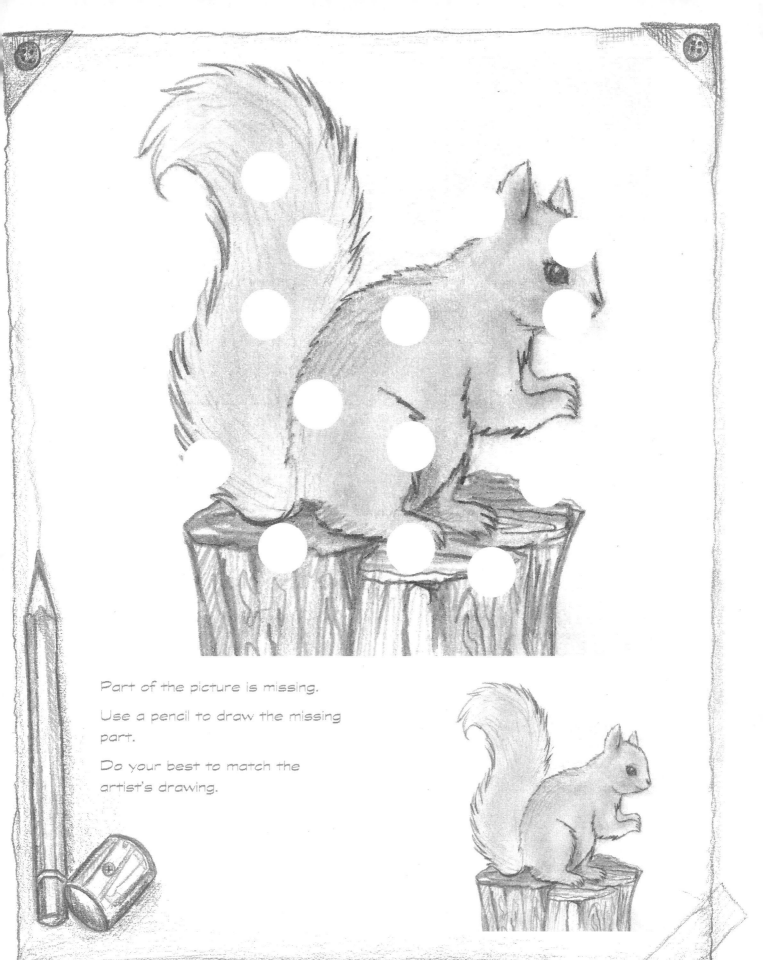

Part of the picture is missing.

Use a pencil to draw the missing part.

Do your best to match the artist's drawing.

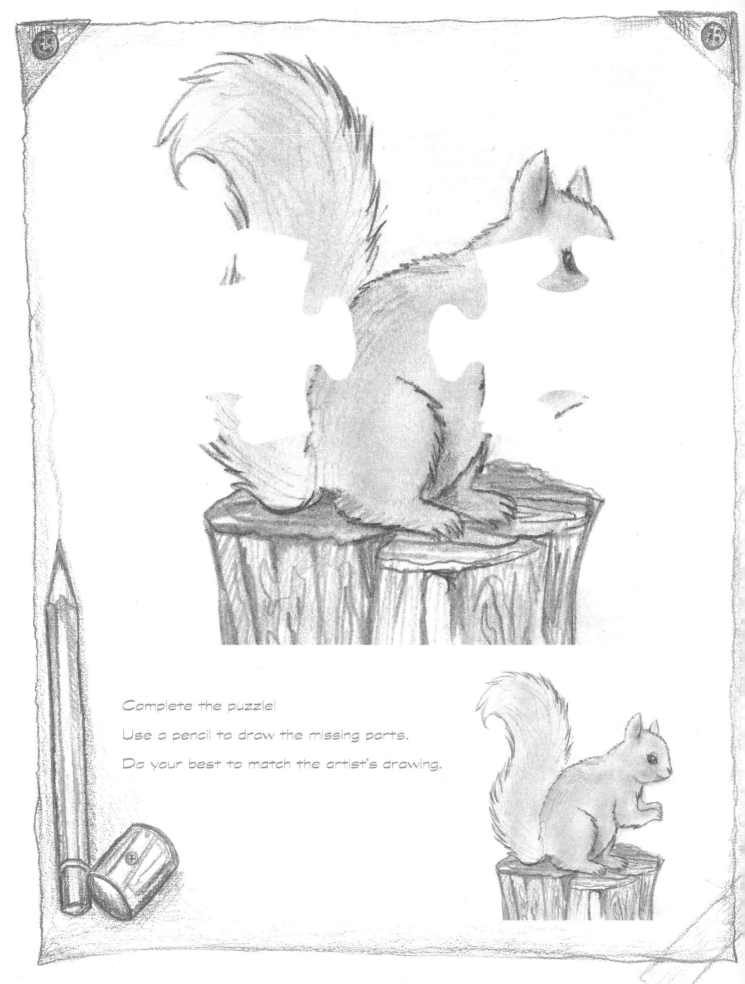

Complete the puzzle!

Use a pencil to draw the missing parts.

Do your best to match the artist's drawing.

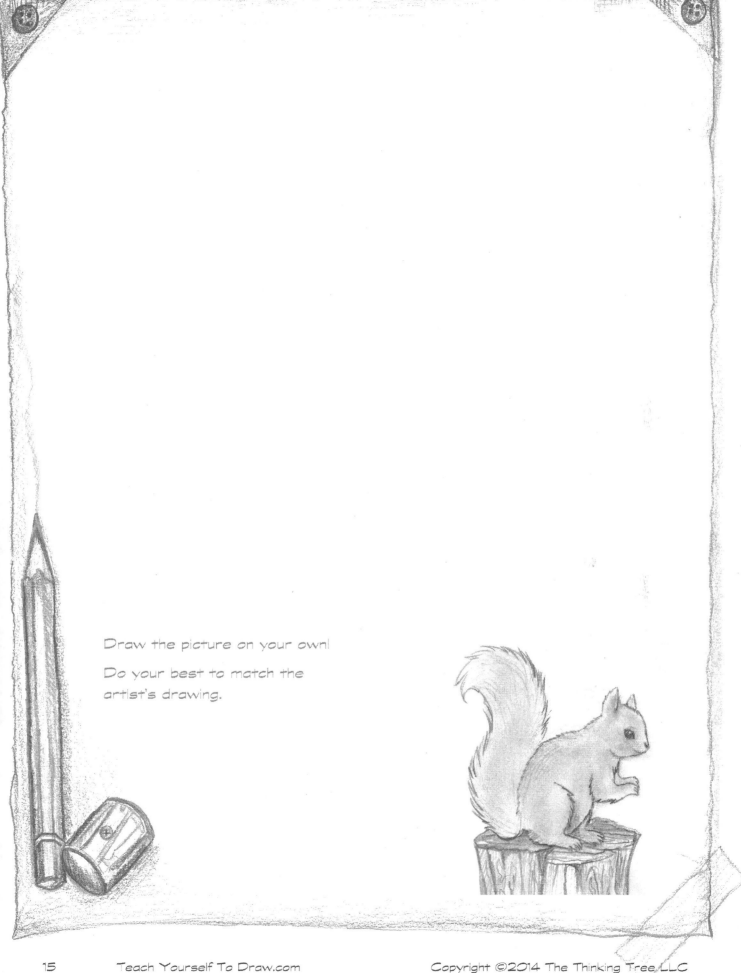

Draw the picture on your own!
Do your best to match the artist's drawing.

Now that you are learning to draw like an artist,
it's time to keep practicing!

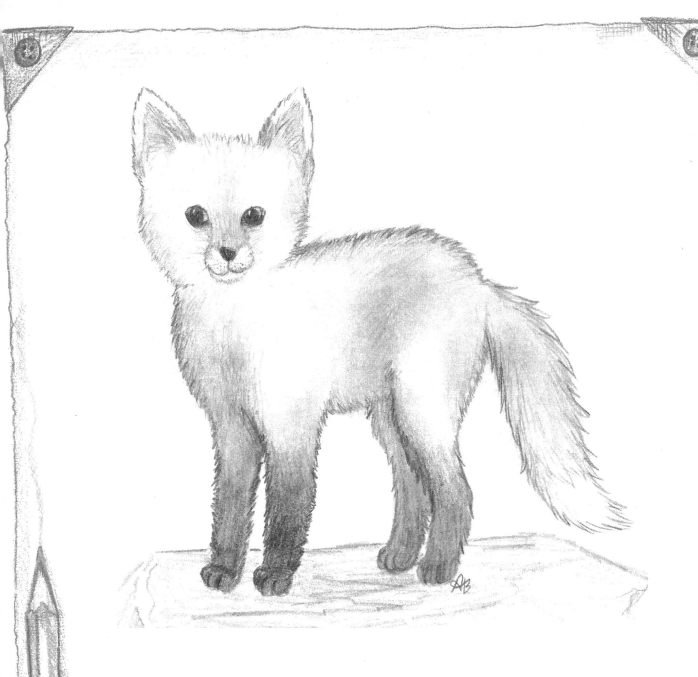

Red Fox Pup

Take a good look at this drawing. Look at all the little pencil strokes that make up this picture. Sometimes an artist uses the tip of the sharp pencil to draw. Sometimes she tilts the pencil and makes a wider stroke, and sometimes the artist uses a darker pencil and presses harder to make dark lines. Also notice the smooth shading. Can you see how the artist used her finger to carefully blend the fur? Try to figure out how to make pencil strokes just like the ones in the drawing.

Use your pencil now to trace the strokes.

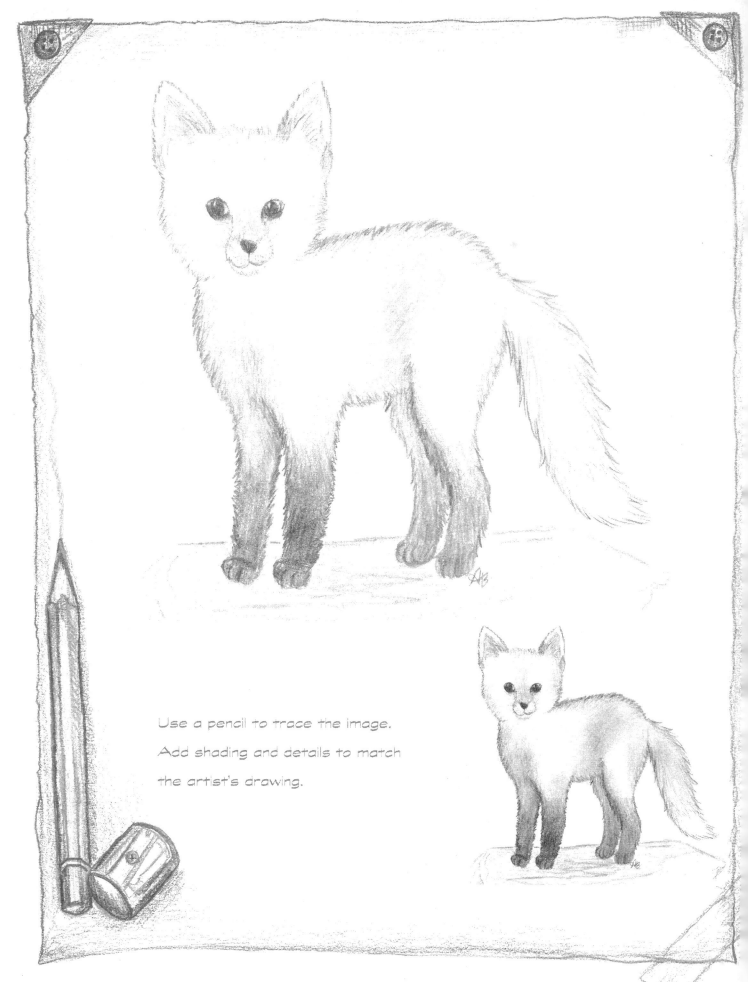

Use a pencil to trace the image.
Add shading and details to match
the artist's drawing.

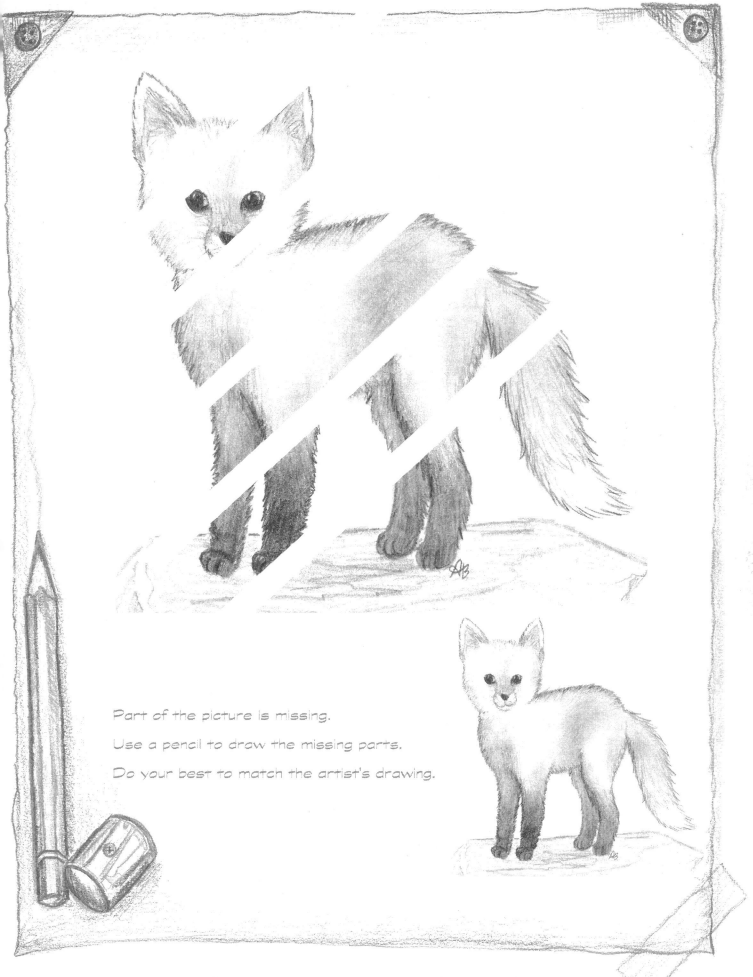

Part of the picture is missing.

Use a pencil to draw the missing parts.

Do your best to match the artist's drawing.

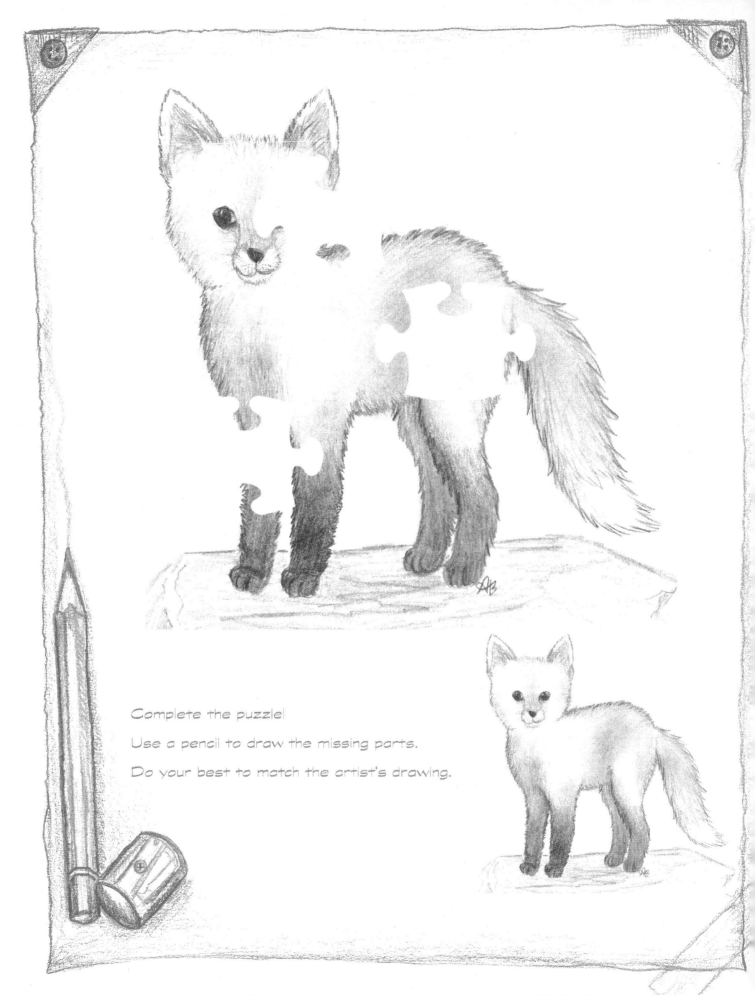

Complete the puzzle!

Use a pencil to draw the missing parts.

Do your best to match the artist's drawing.

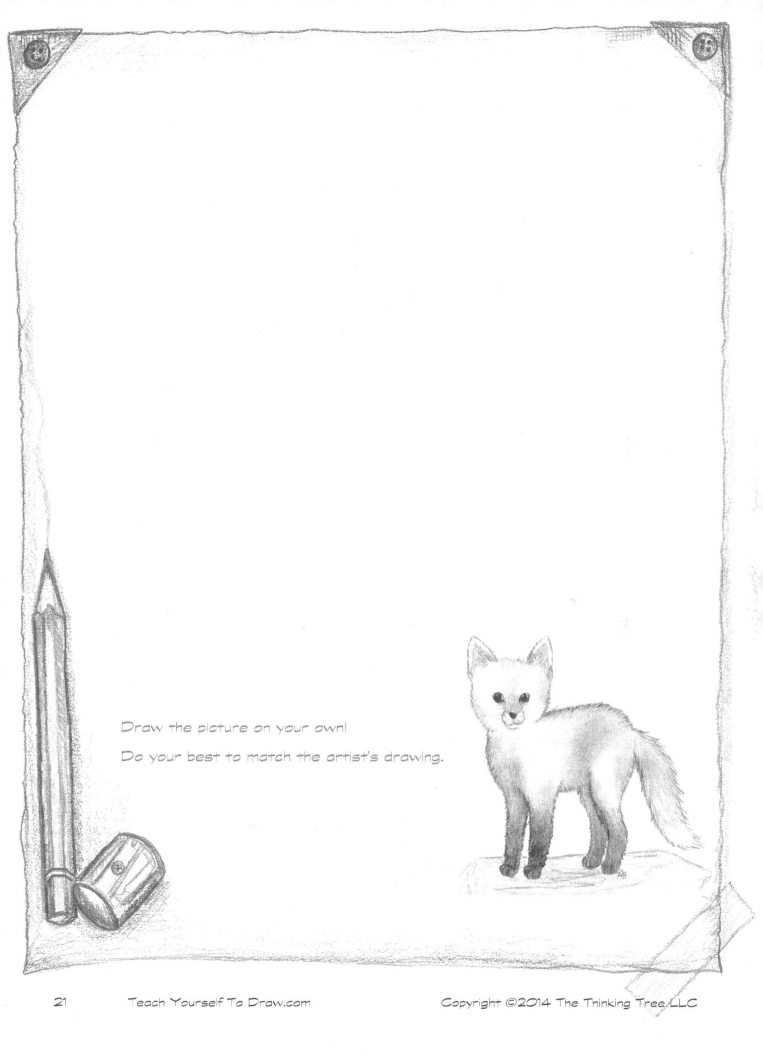

Draw the picture on your own!

Do your best to match the artist's drawing.

Now that you are learning to draw like an artist,
it's time to keep practicing!

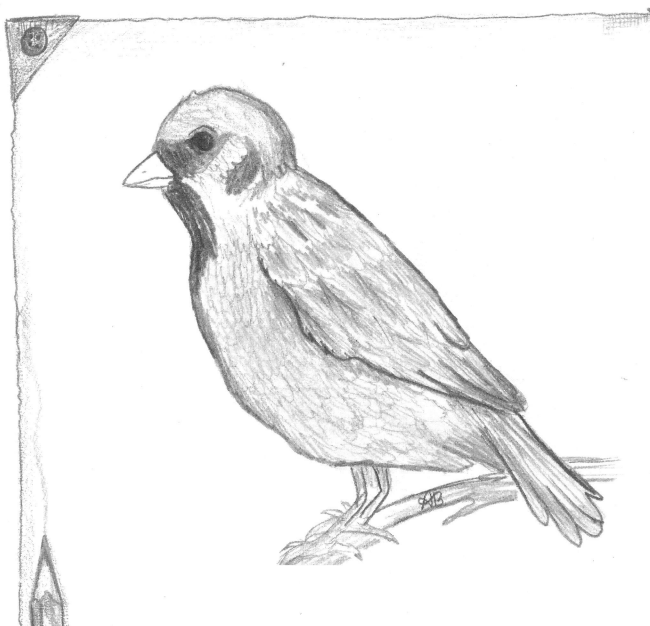

Song Bird

Take a good look at this drawing. Look at all the little pencil strokes that make up this picture. Sometimes an artist uses the tip of the sharp pencil to draw. Sometimes she tilts the pencil and makes a wider stroke, and sometimes the artist uses a darker pencil and presses harder to make dark lines. Also notice the smooth shading. Can you see how the artist used her finger to carefully blend the feathers? Try to figure out how to make pencil strokes just like the ones in the drawing.

Use your pencil now to trace the strokes.

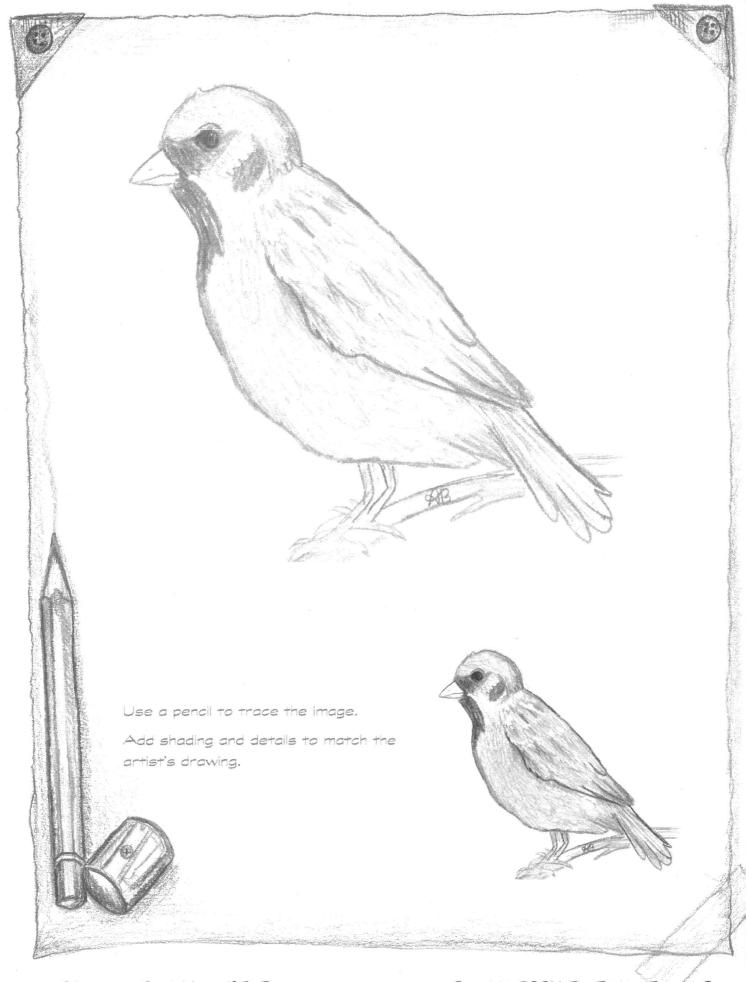

Use a pencil to trace the image.

Add shading and details to match the artist's drawing.

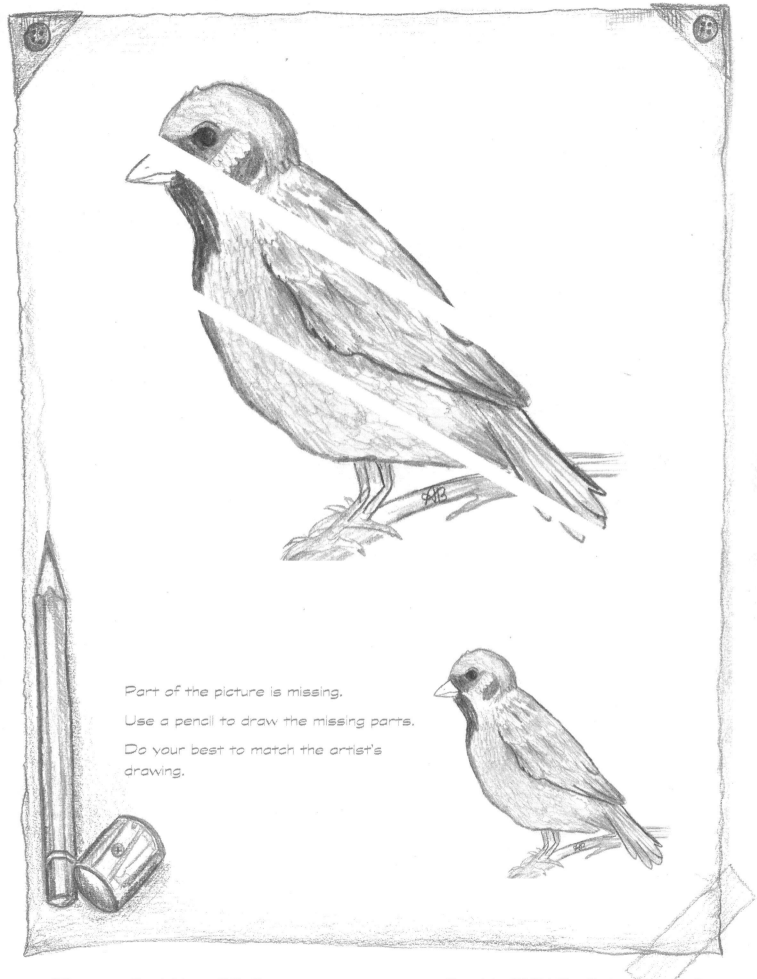

Part of the picture is missing.

Use a pencil to draw the missing parts.

Do your best to match the artist's drawing.

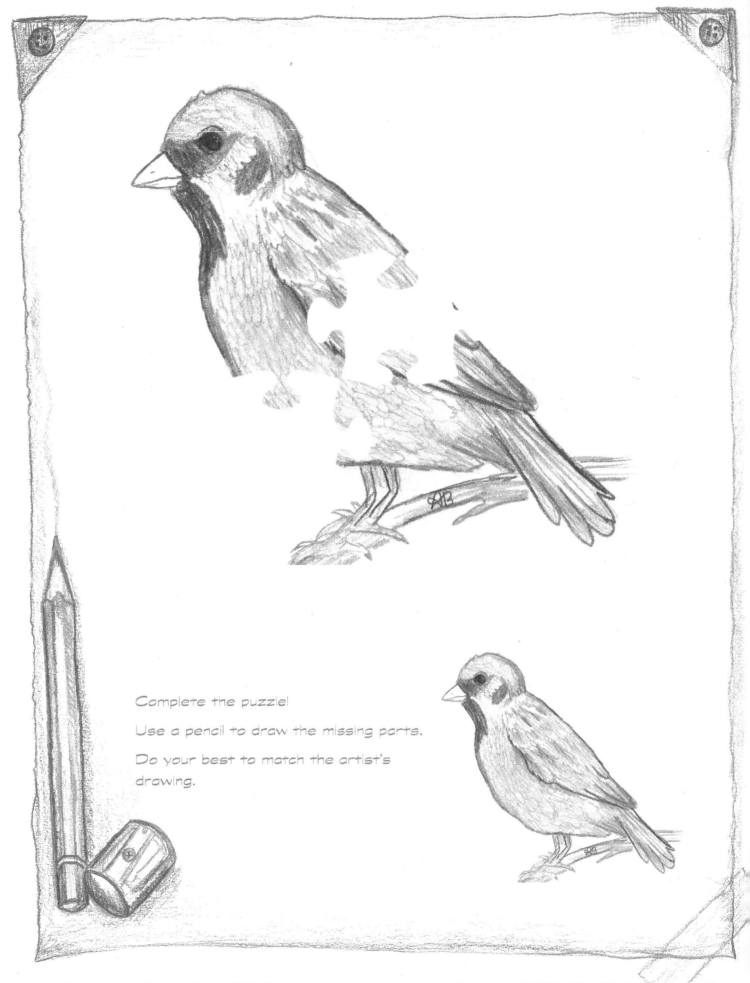

Complete the puzzle!

Use a pencil to draw the missing parts.

Do your best to match the artist's drawing.

Teach Yourself To Draw.com

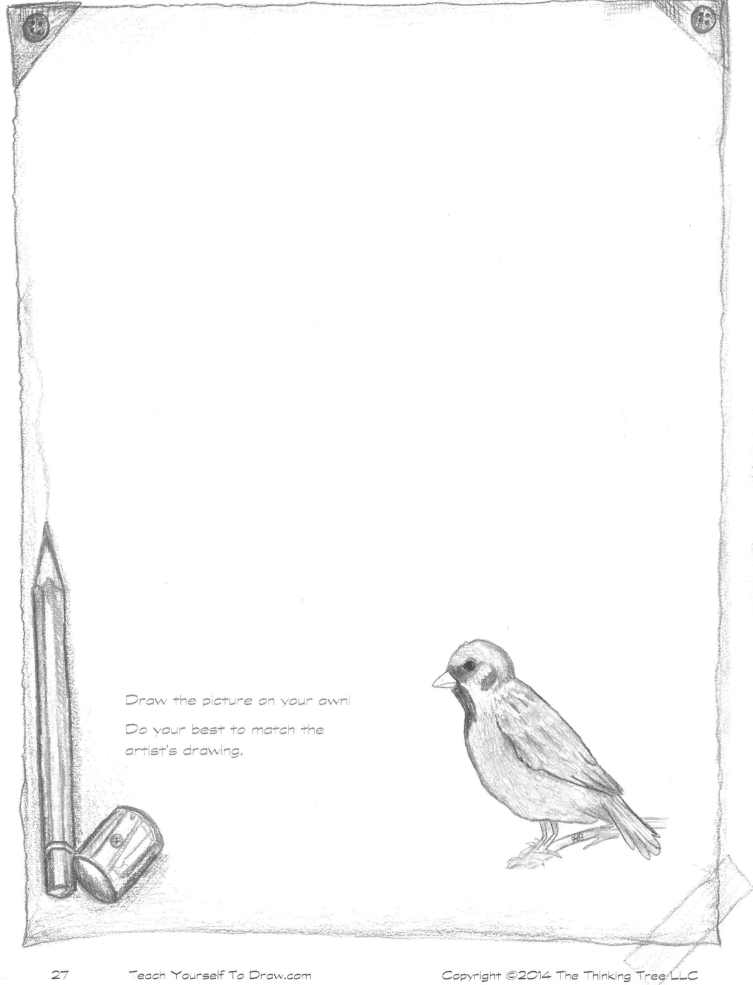

Draw the picture on your own!
Do your best to match the
artist's drawing.

Teach Yourself To Draw.com

Now that you are learning to draw like an artist,
it's time to keep practicing!

Teach Yourself To Draw.com

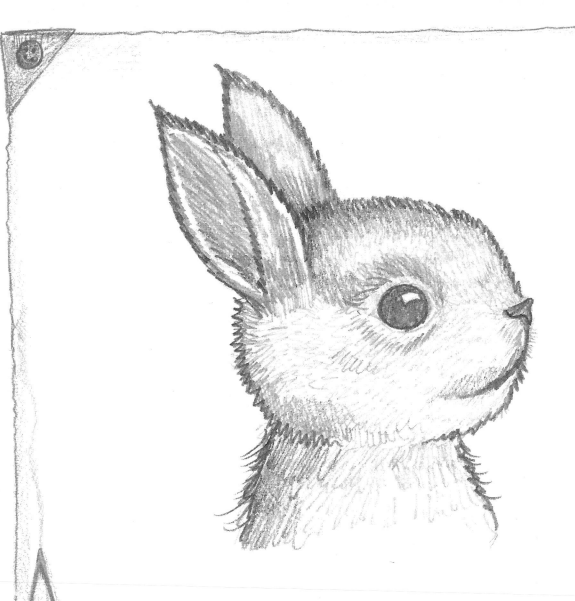

Baby Bunny

Take a good look at this drawing. Look at all the little pencil strokes
that make up this picture. Sometimes an artist uses the tip of the
sharp pencil to draw. Sometimes she tilts the pencil and makes a
wider stroke, and sometimes the artist uses a darker pencil and
presses harder to make dark lines. Also notice the smooth shading.
Can you see how the artist used her finger to carefully blend the fur?
Try to figure out how to make pencil strokes just like the ones in the
drawing.

Use your pencil now to trace the strokes.

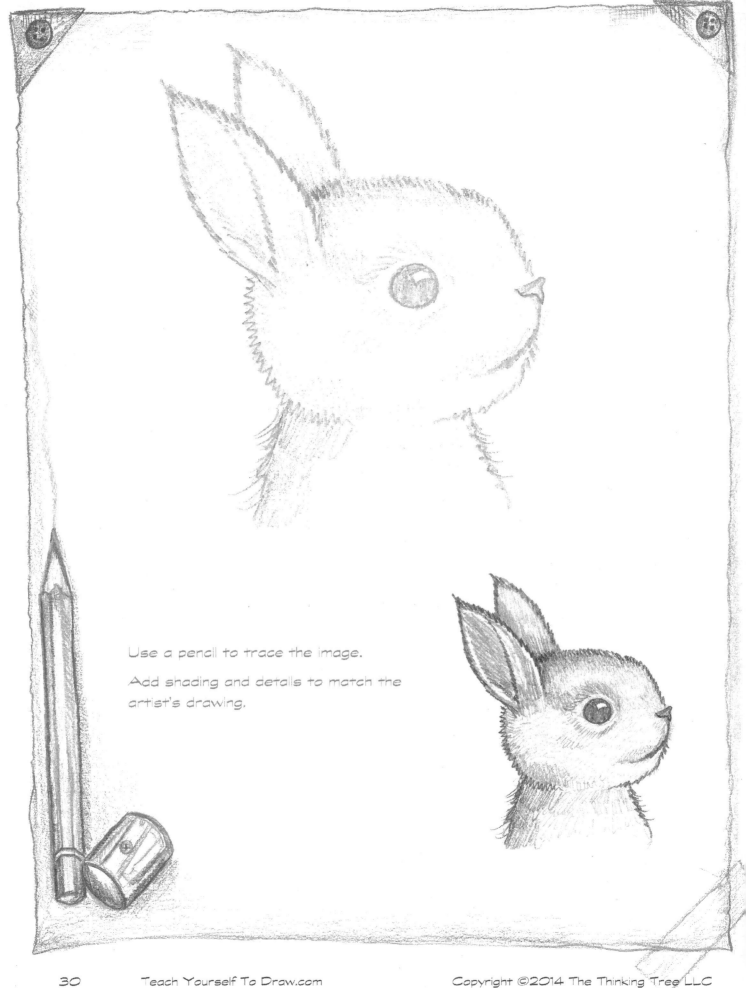

Use a pencil to trace the image.

Add shading and details to match the artist's drawing.

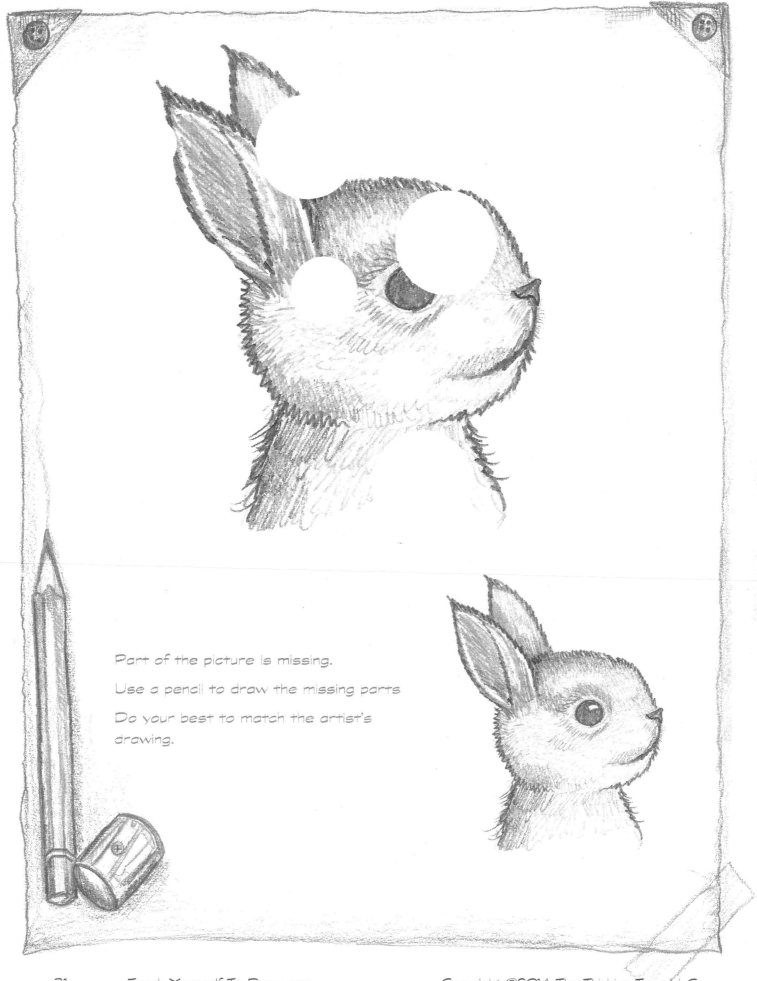

Part of the picture is missing.

Use a pencil to draw the missing parts

Do your best to match the artist's drawing.

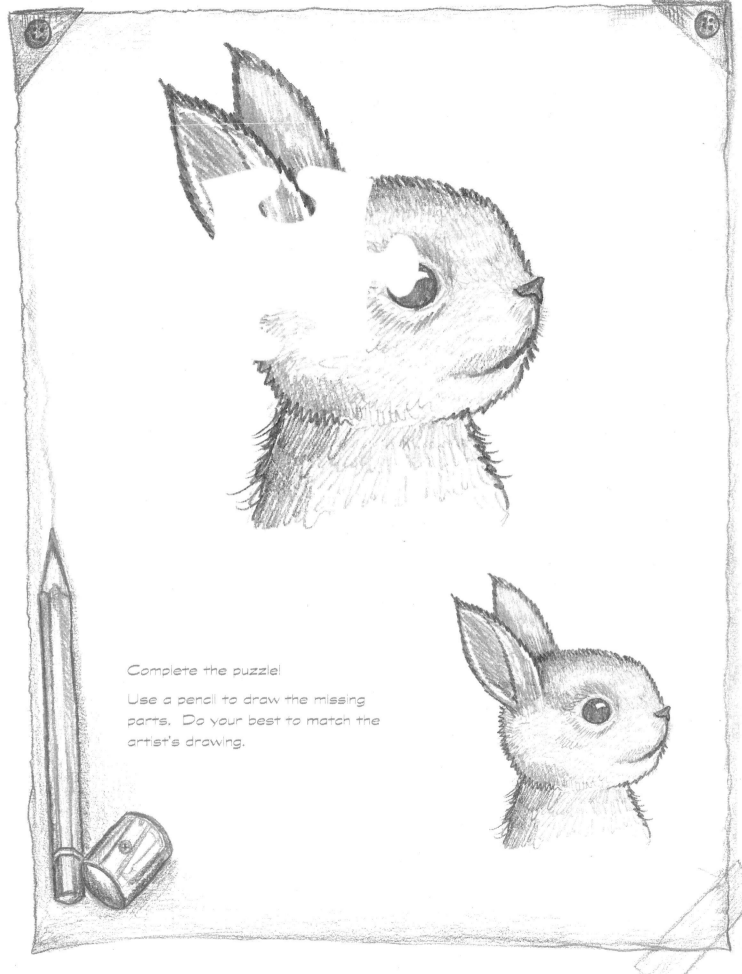

Complete the puzzle!

Use a pencil to draw the missing parts. Do your best to match the artist's drawing.

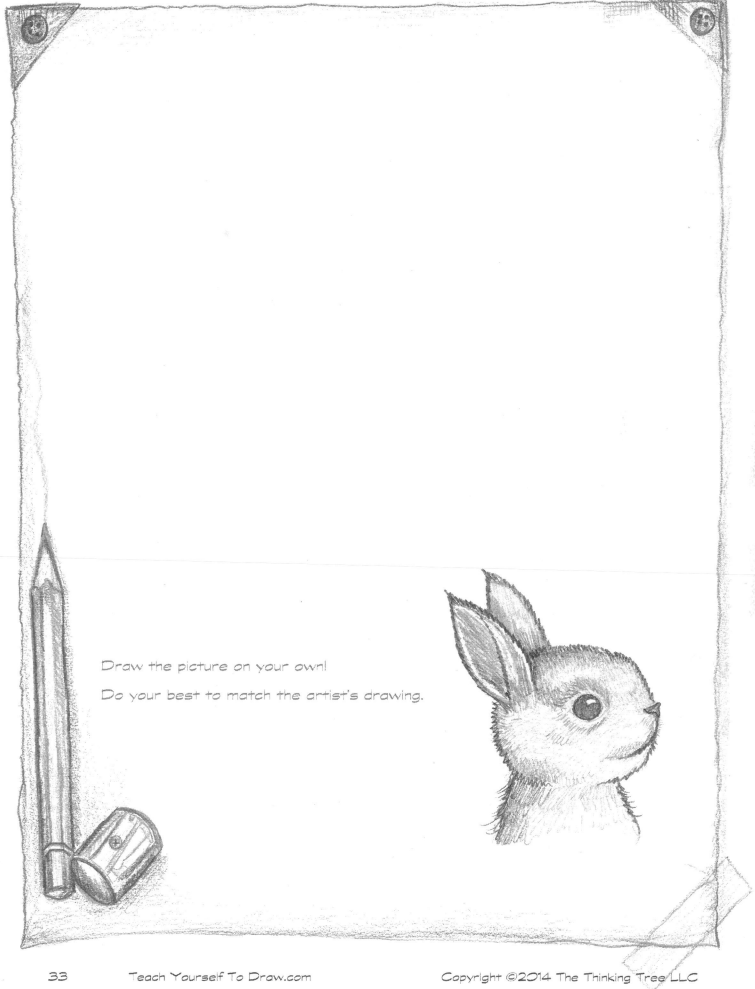

Draw the picture on your own!

Do your best to match the artist's drawing.

Now that you are learning to draw like an artist,
it's time to keep practicing!

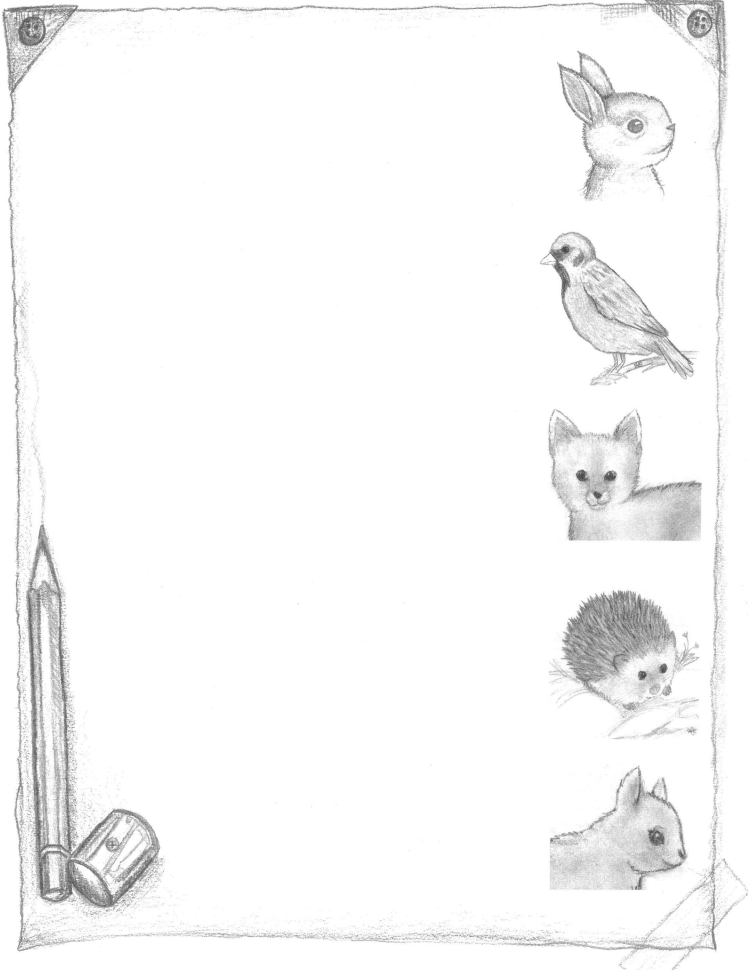

Teach Yourself To Draw.com

Keep Practicing!

Now that you have learned to draw forest animals, try one of our other books!

What do you want to learn next?

Wild Cats

Farm Animals

Sea Creatures

Cats & Kittens

Puppies

Horses & Ponies

Forest Animals

Birds

Lizards

Bugs

Pets

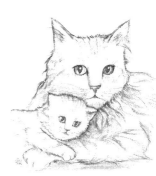

SHARE your ART!

Take a picture of your best drawing and post it on our Website!

Sometimes we have CONTESTS!

TeachYourselfToDraw.com

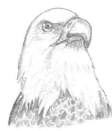

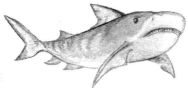

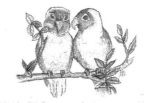

DRAW

All you need are two sharp pencils, an eraser, a pencil sharpener, and a desire to become a better artist!

Pencil Types: #2 and 5B

Become your own art teacher with 5 easy lessons!

Made in the USA
Coppell, TX
26 August 2020